Things a
Woman
Should Know
About Seduction

For Scarlet women everywhere, particularly
Sarah Hedley, Nahid de Belgeonne,
Carolyn Saunders and Jean Dubberley
(my Mum and a great inspiration).
And for Scarlet man, Gavin Griffiths.

Things a
Woman
Should Know
About Seduction

Emily Dubberley

BARRON'S

First edition for the United States and Canada
published 2005 by Barron's Educational Series, Inc.

First published in Great Britain in 2005 by Prion,
an imprint of the Carlton Publishing Group,
20 Mortimer Street, London W1T 3JW

All inquiries should be addressed to:
Barron's Educational Series, Inc.
250 Wireless Boulevard
Hauppauge, New York 11788
http://www.barronseduc.com

Library of Congress Catalog Card No.: 2005921547
International Standard Book No.: 0-7641-5906-2

Printed and bound in Singapore
9 8 7 6 5 4 3 2 1

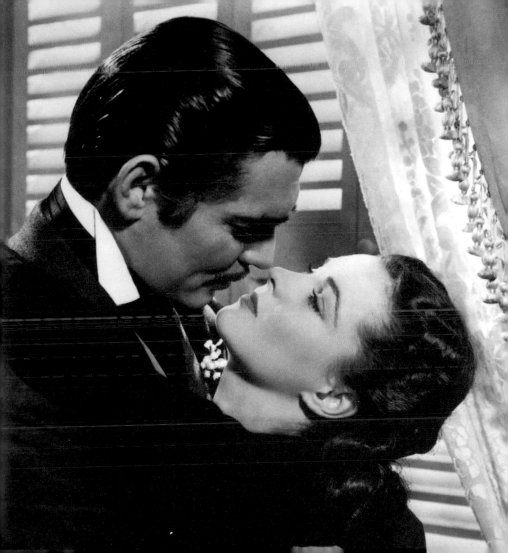

Contents

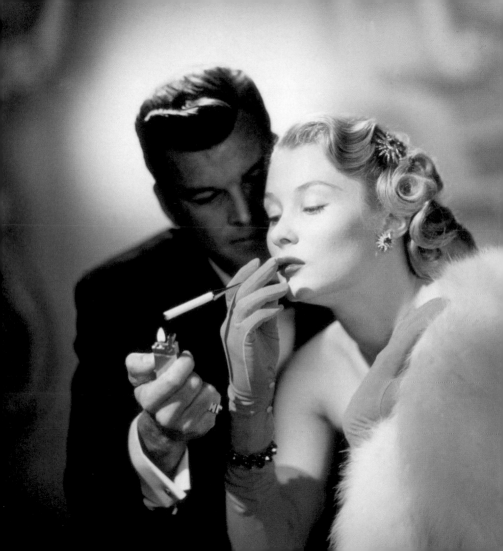

Seduction: An Art, A Science, A Lifestyle...

"It isn't what I do, but how I do it. It isn't what I say, but how I say it, and how I look when I do it and say it."

– Mae West's motto

Seduction: simply saying the word aloud forms your mouth into a kiss – and rightly so. One of the main

reasons we were put on this earth was to find our perfect partner, and knowing those essential seduction tricks makes it so much easier.

Meaning "to tempt or attract," there's more to seduction than merely going up to a man and saying, "You've got me." Seduction is an art, and a science. It's about inner confidence: knowing your own body and using every nuance of it to attract the man of your dreams. It's about flirtation, pheromones, and fluttering those eyelashes.

Far from being a passive way of behaving, seduction is empowering for women; it's about using what you've got to get what you want. And what could be a better demonstration of your power than that?

"Seduction is always more singular and sublime than sex and it commands the higher price."

— Jean Baudrillard

Seduction is easier now than ever before, with makeup, push-up bras, endless aphrodisiac aromatherapy oils, and exotic boudoir furnishings all easily available. You can buy fake pheromones (bad idea) and silk lingerie (good idea). There are myriad herbal supplements to apparently boost your sensual potential, make your skin glow, and make your hair shine. And if you're really desperate, there's even cosmetic surgery to change the way you look.

But you don't need to spend money in order to be the ultimate seductress. While seduction may not come naturally to you, the good news is that everyone has the ingredients. You just need to harness your natural assets.

No matter what size or shape you are, you can be a seductress: Marilyn Monroe was a voluptuous size sixteen, while Scarlett O' Hara had an eighteen-inch waist (after giving birth!), and both knew exactly how to tempt a man. Whether you're svelte or curvaceous, you have that all-

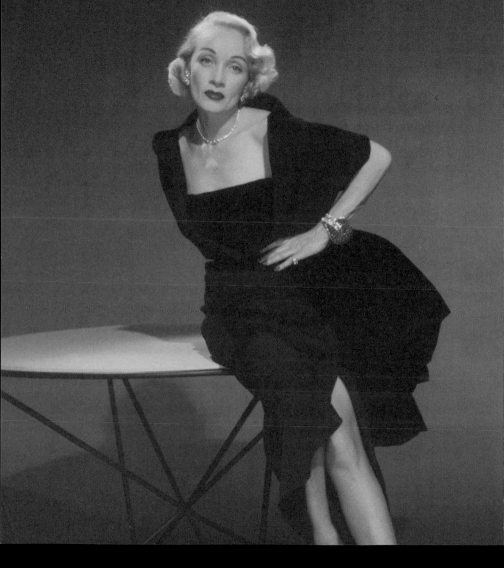

important ingredient: your feminine wiles. What hope does a poor man have against those?

"The average man is more interested in a woman who is interested in him than he is in a woman — any woman — with beautiful legs."

– Marlene Dietrich

All's fair in love and war, and a good seductress makes sure that every weapon in her arsenal is primed and ready for action at all times: her boudoir, body, and brains.

A good seductress is no bimbo; she knows the mind is all-important when it comes to seduction. She's got an understanding of psychology, linguistics, and all those other subliminal things that make men tick. And she uses them all to get what she wants.

· 13 ·

Seduction isn't about being brazen and overt. It's about subtle glances, sensual yet innocent touches, and body language tricks that lure a man into your lair like a black widow without the unattractive eating habits.

> *"When she raises her eyelids it's as if she were taking off all her clothes."*
>
> – Colette

Like it or not, men still often feel better if they make the first move, so a true seductress knows exactly how to make a man feel like he's seduced her.

Despite its reputation, seduction isn't primarily about scx. It's about attracting a man, sure, but it's more about winning his love than merely getting him into bed. Seduction is a subtle enticement rather than an open invitation.

And don't make the mistake of thinking that seduction is only about attracting a partner in the first place. Once you've found a partner, you can still use seduction techniques to keep the spark alive between you – and to keep yourself feeling like the sensual woman that you really are.

> *"A woman should be cook in the kitchen, a maid in the living room and a whore in the bedroom."*
>
> – Jerry Hall

Forget the stereotype of red-painted talons and heady perfume: Your seduction style should be tailored to fit your personality. For some women, being a vampish vixen works, but others will find that a coy approach is better for them. Know your own sex style and be comfortable with who you are. Once you've found your inner sex goddess, you can set her free on the men of the world.

· 15 ·

Some things are never seductive: bedsocks, bad breath, drunkenness, and nagging. Some things are always seductive: lingering eye contact, running a cube of ice over your skin in hot weather, classy lingerie, and laughter – as long as it's not when a man's first undressed for you.

A seductress oozes confidence. She loves herself and, in doing so, makes other people love her. That doesn't mean she's arrogant; indeed, one of her skills is listening to other people. But she knows why she's fantastic, and doesn't let anyone convince her otherwise.

No one is ever entirely sure what a seductress does in the privacy of her boudoir – although they're desperate to find out. She exudes an air of mystery, hinting at dark pleasures
that a very lucky man may get to sample.

She isn't ashamed of her sexuality, but neither does she brag to the world about her encounters.

You know the way that some women can walk into a room and have every man gaze at them adoringly, while others are seen as "one of the boys" even when they're wearing a seriously slinky frock? Or the way that some women always seem to be out on a date with a gorgeous new man, leaving their friends wondering what their secret is? Just follow the tips in this book and you can be that woman: the ultimate seductress.

Though, of course, men will think that they are the ones seducing you...

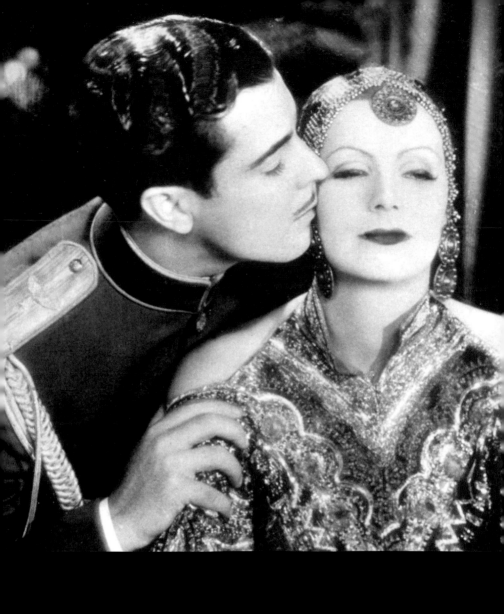

Great Seductresses from History

The seductress isn't a new invention: She's been documented in some of the very earliest texts. At some times in history she's been seen as worthy of worship. At other times she's been a figure of scorn or derision. But no matter how she's perceived, all seductresses have one thing in common: power. Men are unable to resist when she turns on her charm.

Whether they rely on brains, beauty or brazen outlook, all these women are sisters in seduction. So who better to steal a few tricks from?

Aphrodite

As goddess of love, you can't get a much better seductress than Aphrodite. Although she's one of the Greek "virgin" goddesses, it's a bit of a misnomer. Virgin actually meant "beholden to no man" in those days, rather than the current definition, so you can rest assured that she didn't sleep alone.

Aphrodite was – quite literally – a sex goddess, who fell in love frequently and easily. She was an innocent flirt, with an easy sensuality and plenty of confidence. Anyone she fell for was treated as if they were the most interesting, gorgeous, and intelligent person she'd ever met – a seduction method that still works today.

Aphrodite was articulate, charming, and creative. Preferring variety to commitment and intense passions to enduring love, she gravitated toward bad boys – just going to show that even goddesses make mistakes. She acted first and thought later. But she had a lot of fun while she was doing it.

Lilith

Represented as a dark figure in Jewish lore, Lilith was Adam's partner before Eve came along. However, she didn't like being treated as a second-class citizen because of her gender, she so decided to leave him.

Lilith managed to escape from the Garden of Eden by using the name of Yahweh – the secret name for God, considered to be a word of great power and banned from use in Judaism – which she had obtained by seducing God himself.

Using this power, she fled to a cave by the Red Sea and hooked up with Asmodeus, the king of demons – bearing him a hundred demon children daily. God's angels threatened to kill her children if she didn't return, and she countered with a threat to Adam's children, getting a reputation as a baby-killer.

Nonetheless, Lilith was one of the earliest feminists – and she seduced God; you've got to admire the girl for that, if nothing else.

Cleopatra

Renowned for using her sexuality to achieve power, Cleopatra had seduction down to a fine art. She would dress like a goddess – literally (they were big on all that "goddess come to life" stuff in those days). Rather than showing everything, she dressed in a deliberately provocative way with only glimpses of flesh on display, to make men wonder what lay beneath. She created a fantasy figure that all men

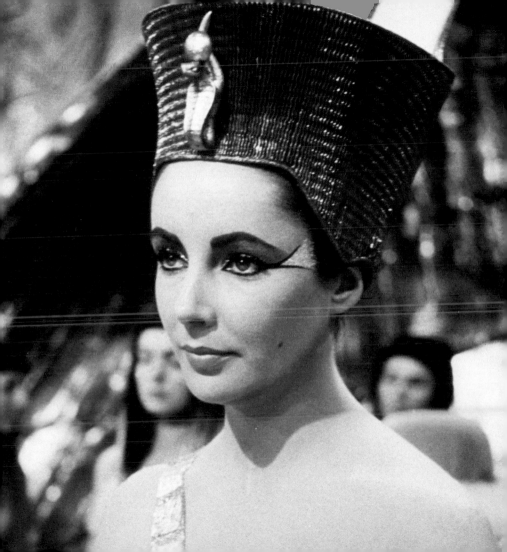

wanted to possess. She's even rumored to have performed fellatio on hundreds of soldiers in a single night.

Another crafty trick Cleopatra used was taking a man from his usual life and introducing him to her decadent world – for example, luring Caesar away on an opulent trip down the Nile and plying him with sensual pleasures. As a man became hooked on her comforts, she would withdraw, forcing him to pursue her in order to get back the life to which he had become accustomed. And all this years before *Men Are from Mars, Women Are from Venus* was ever written.

Cleopatra recognized that sex was power and seduction was her weapon. Needless to say, she spent a long time practicing for war.

*"My honor was not yielded,
but conquered merely."*

– Cleopatra

Nell Gwynn

Starting out as an orange-seller at the Theatre Royal in Drury Lane – a job undertaken by pretty, flirtatious girls (who often did more than just flirt with the audience) – Nell Gwynn used her skills as a seductress to become mistress to Charles II.

In a classic example of "sleeping her way to the top" (not a thing in which to follow her lead), Gwynn first became the mistress of the actor Charles Hart. She landed a part in a play, *The Indian Emperor*, and her performance attracted the attentions of Charles Sackville, 6th Earl of Dorset. Soon she'd moved onward and upward to date him and experience the pleasures of the Royal Court.

Nell met King Charles II when she was at the theater with yet another suitor. The King liked her quick wit and invited her to dinner after the show – taking a steward along to distract her beau. When the meal was finished,

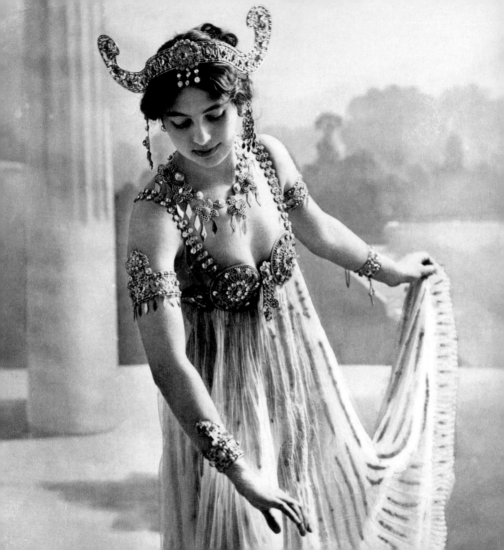

the King discovered that he had no money and made Nell's date pay for the meal. Nell burst into laughter, joking, "Oddsfish! But this is the poorest company that ever I was in before at a tavern!" While everyone else was horrified at her candor, the King was charmed and immediately fell in love with her. She became his mistress and ended up bearing him two sons.

Gywnn clearly had the King well and truly under her spell. His final request on his deathbed was, "Let not poor Nelly starve." This request resulted in a pension that assured her a comfortable life until her own death two years later.

Mata Hari

Margaretha Geertruida Zelle, or Mata Hari as she's more commonly known, was the spy who used seduction to get secrets. She started her career as an exotic dancer in France. As her fame grew, she started to move in the highest circles of Europe, traveling to many different countries.

The French saw an opportunity to use her and asked her to extract secrets from the Germans. However, despite her contemporary infamy as a spy, Mata Hari wasn't all that good at it. During her very first mission she was arrested by the British Intelligence Service.

It soon transpired that she was being paid by German army officers – apparently for her "company." The French found this overly suspicious, so when she tried to cross the French border – to visit another lover – she was arrested and interrogated by the French Secret Service. She never admitted that she was a double agent, working as a spy for the Germans under the name H21, but she was found guilty and shot by a firing squad on October 15, 1917.

Mae West

Brash, bawdy, and blonde, Mae West was the queen of the pithy one-liners. Known for salacious eye-rolling and *double entendres*, by the age of 14 she was being billed as the "Baby Vamp."

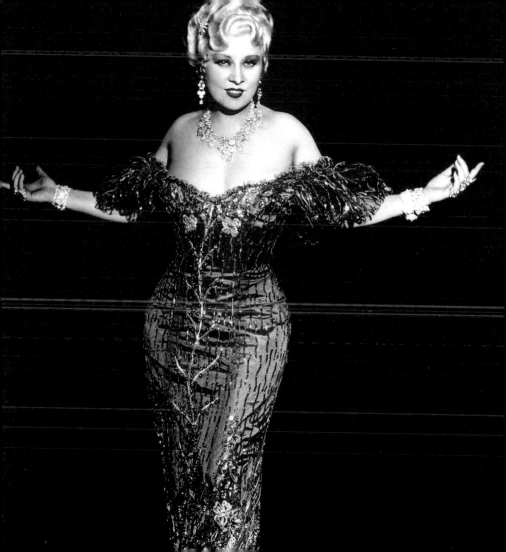

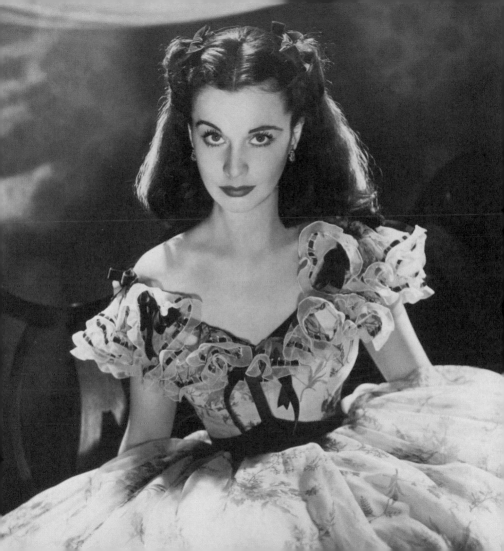

In 1926, when she was in her early thirties, West wrote, produced, and directed the Broadway show *Sex*, which got her arrested for obscenity. She followed this with a play called *Drag* the following year – banned on Broadway for being about homosexuality.

In 1932 she signed with Paramount and was incredibly successful – but still saucy enough that the Hays Office brought in a new code of censorship in 1934 to counter her brand of smut.

West's sense of humor was a key part of her attraction; she combined innuendo with self-deprecation and always had a witty comeback to any man.

Scarlett O'Hara

Famous for eyelash fluttering and coy flirtation, Scarlett O'Hara was far from an innocent belle. She knew what she wanted and she went out to get it. And O'Hara wasn't

afraid to suffer to be beautiful; she was squashed into terrifyingly tiny corsets to get that oh-so-important waist–hip ratio (of which more later) down to true hourglass levels.

Using her feminine wiles in all their glory, Scarlett O'Hara epitomized the Southern Belle. And while the man she loved may have claimed that he didn't give a damn, she never gave up.

So you can see, seductresses are a part of history – and these are only a select few. From Marilyn to Madonna, Brigitte Bardot to Beyoncé, some women have always known that their sensuality is a powerful force. Through harnessing your sexual side, you too can know that power.

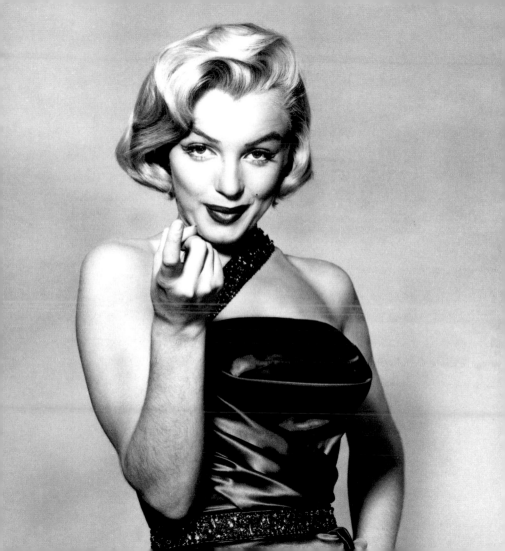

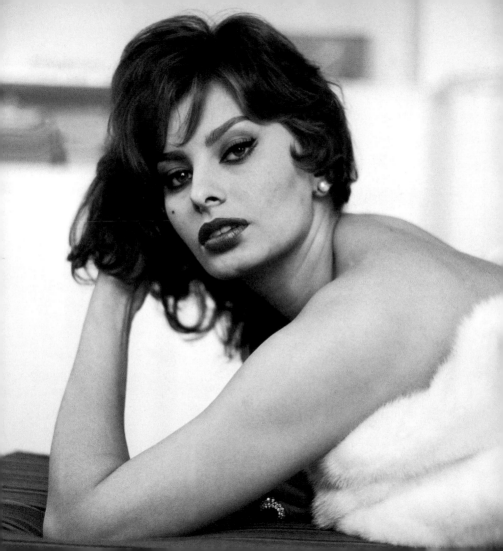

Don't Dream It, Be It

There are as many types of seductress as there are men to seduce; what you need to do is let your own inner seductress free. The best way to behave in life is naturally and, no matter how deep down it is, every woman has a super-vixen somewhere inside her ready to leap out.

It's not about slapping on some lipstick and a micro-mini skirt. Seduction involves the mind much more than the body; after all, the brain is the largest sex organ that humans have. So, first of all you need to get your mind into seduction mode.

Before you even think about seducing someone, make sure you're ready for it. While you're still pining over your ex-boyfriend, forget about seduction and enjoy going out with your friends instead; otherwise, you'll just end up weepy at the end of the evening because you haven't managed to attract anyone. If you do end up in that situation, remember, the only reason you're on your own is because you're not ready to be with someone else quite yet, so give it time.

It's almost impossible to seduce someone if you're feeling like rubbish. You need to ooze sensuality rather than look as if you're worrying about what to do next. When you're getting ready for an evening out, make sure you've primed

your body perfectly (see page 97) and are wearing underwear that makes you feel fabulous (see page 109). Simply knowing that you're perfectly prepared for seduction – and feeling your buffed skin brush against your sensual lingerie – will help you in your mission.

"I don't try to be a sex bomb. I am one."

– Kylie Minogue

If you have anything that always makes you feel fabulous – a piece of jewelry, item of clothing, or whatever – then wear it. It's even better if it's a conversation piece; the more ways you have to start chatting with someone, the better.

Confidence is one of the most attractive assets you can have – so if you don't have it, fake it. Everyone feels insecure to some degree. The trick you need to master is looking as if you don't. Over time, this will start to feed

into the way you feel about yourself and, before you know it, you'll feel as confident as you look.

"I think the quality of sexiness comes from within. It doesn't really have much to do with breasts or thighs or the pout of your lips."

– Sophia Loren

Seduction mantras to run through your mind

While you'd never actually say any of these out loud, a bit of positive visualization can go a long way. Try repeating the following mantras before you go out, or if you find yourself stuck on your own and feeling down at any point in the evening.

They'll subliminally boost your confidence, making you seem more attractive.

Even better, if you're immersed in thought, you'll look mysterious and aloof, which is always a winner when it comes to attracting men.

- I am gorgeous.
- I have the pick of every man in the room.
- I am the ultimate lover.
- My outfit is stunning.

Alternatively, just let saucy thoughts run through your mind. Your pupils will dilate (get bigger), which makes you look more attractive – though you may not want to be interrupted if the thoughts are that good...

A great way to boost your confidence is by making a list of all your ultimate assets. This is no time to be coy. Everyone has something to be proud of. You might have a super-sexy laugh or a stunning smile. You could have perfect curves or legs to die for. So acknowledge your assets to yourself and you'll start to foster that inner glow.

"If I'm going to be a symbol of something, I'd rather it was sex than some of the things we've got symbols of."

– Marilyn Monroe

Another handy technique when you're going out for the night is to think "I wonder if there will be anyone there whom I'll find attractive?" rather than, "I wonder if anyone will find me attractive?" This subtle shift in attitude will help you feel better about yourself and look less needy. Rather than waiting for someone to find you appealing,

you're taking a more active role. And in doing this you're also less likely to end up with someone who, deep down, you know isn't good enough for you – or, worse, thinks you're not good enough for him and treats you accordingly.

Remember, there are 95 million singles in the United States, so your odds of finding someone to seduce are high. If you believe that you're a seductress, you'll be a seductress. So what are you waiting for? Set your sensuality free.

What's Your Seduction Style?

Now that you've pumped up your confidence, try to find your own seduction style. Some women use Marlene Dietrich style husky whispers with "Come up and see me some time," while others prefer the coy glances of Marilyn Monroe. The feisty and fearless approach of Mae West might be the method that works for you. Or maybe you prefer relying more on brains than bravado, Lauren Bacall style. Not sure which way to go? This guide should help you identify the seduction style that's most suited to you.

The Vamp

Classic vamps: Vivien Leigh, Marlene Dietrich

You wear: Black, of course, darling. Whether you're wearing funky Capri pants or a classic little black dress, your clothes are designed to cling, emphasizing your womanly charms. The idea of leaving the house without makeup on is anathema; your eyes are emphasized with black eyeliner and lashings of mascara, and your nails – or, rather, talons – are always perfectly manicured, and painted red to match your lipstick. You always wear perfume: a heady and sensual blend to match your personality.

You enjoy: Cocktails, dancing, and eating out in expensive restaurants.

You read: Anaïs Nin, Henry Miller, and sex manuals; you're always looking for new bedroom moves. The books are hidden so that men assume your talent is innate.

Typical pick-up line: Pick-up lines? Never. You expect a man to approach you – but your body language will communicate your desires quite clearly.

How to increase your vamp rating: Invest in some seductive accessories – a cigarette holder, long gloves, or a fake fur stole. Lower your tone of voice, and perfect your "come to bed" gaze (see page 142 for details).

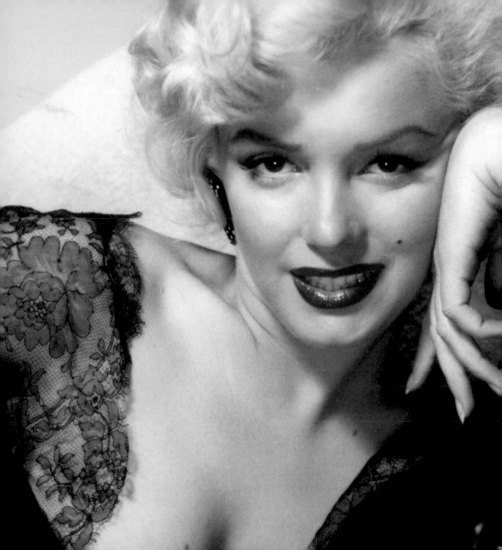

The Innocent

Classic innocents: Marilyn Monroe, Penelope Pitstop

You wear: Super-feminine dresses that conceal more than they reveal, or cute shirts tied at the waist over figure-hugging jeans. Your makeup is natural and your perfume is light and floral.

You enjoy: Walks in the park, picnics and going to the zoo.

You read: Chick-lit and self-help books.

Typical pick-up line: "Could you help me change my tire? It's too complicated for little old me."

How to increase your innocent rating: Work on your giggle. Practice blowing bubbles with bubblegum. Don't fill your room with teddy bears; you can go too far.

The Intellectual

Classic intellectuals: Lauren Bacall, Katharine Hepburn

You wear: Elegant suits with silk shirts, or black polo-necks with fitted trousers.

You enjoy: Conversation, reading, and philosophy.

You read: Anything and everything, but with an emphasis on classics and nonfiction. You read to learn as much as for leisure.

Typical pick-up line: "Where do you stand on Plato's theory of love?"

How to increase your intellectual rating: Get down to the library and start reading. Start taking your coffee black, and strong. Carry a notepad with you to write or sketch your innermost thoughts.

The Brazen Babe

Classic brazen babes: Mae West, Madonna

You wear: Plunging necklines, anything figure-hugging.

You enjoy: Parties, karaoke, and being the center of attention.

You read: Who has time to read when there are so many men out there?

Typical pick-up line: "Your place or mine?"

How to increase your brazen babe rating: Get some dirty joke books and study the aphorisms of the great Mae West. Develop the hide of a rhino so that anyone who · 51 · knocks you back gets a pithy one-liner in response.

Of course, you may be a mixture of some of the above styles: a brazen vamp or coy intellectual.

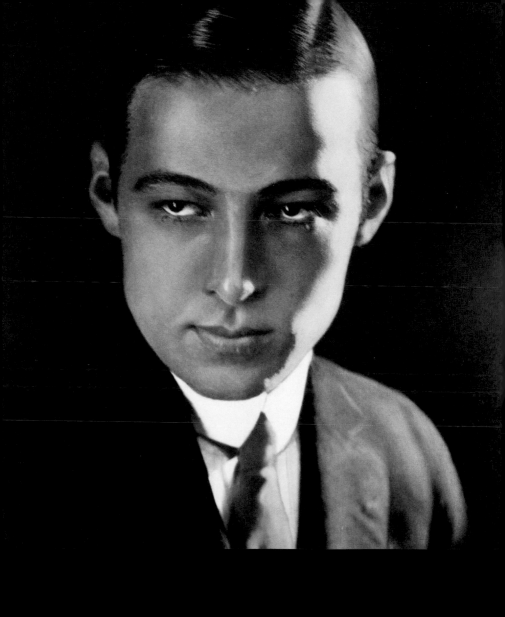

Seductive Superstitions

There are a wealth of superstitions about seduction. For example, if you take an apple and twist the stem while you recite the names of five or six people you could potentially marry, legend dictates you'll marry the person whose name you are saying when the stem falls off. (Note: This may not work if you have Jude Law, Brad Pitt, or George Clooney in your list.)

If you feel like giving fate a helping hand, make a note of these dates in your diary. Who knows? Your seduction attempts could be magically enhanced.

St. Agnes's Eve – January 20

If you want to find out whether you're aiming to seduce the right man, take advantage of a tradition on the Eve of St. Agnes, January 20. You can find out who your future lover will be by fasting all day, then eating a salt-filled egg (nice). If you're not throwing up after that tasty treat, you'll dream of your lover, or so the superstition says.

Valentine's Day – February 14

For pure romance, nothing beats Valentine's Day. According to legend, Valentinus, a Roman priest, was beheaded on February 14 for performing secret marriages. Tradition has it that a girl could dream of her future husband on Valentine's Day Eve by sleeping with four bay or laurel leaves pinned to the corners of her pillow. If you see a squirrel on Valentine's Day, you will marry a cheapskate. But if you see a goldfinch, you will marry a millionaire!

May Day – May 1

Traditionally a time for celebrating fertility and love, it's not all that surprising that there are endless superstitions surrounding May 1. May Day is related to the ancient Roman festival of Floralia. Flora was the goddess of flowers (and the patron saint of prostitutes). Historical celebrations reflected this, with "working girls" putting on naked displays in theaters.

Luckily, the superstition doesn't require you to be quite so overt. If you want to boost your chances of seduction, just get up early and wash with dew collected on May Day morning. It's thought to increase beauty, improve health in the coming year, and help you find love.

If you're getting bored of waiting for the man of your dreams, look for birds' nests on May 1. The number of eggs will tell how many more years you'll be single. Legend also says that if you take a mirror and hold it over a well on May Day, you'll see a reflection of your future husband.

If you're skeptical about all this superstition, just remember, May 1 was Rudolph Valentino's birthday – one of the most famous screen lovers of all time (see page 52). So who knows? Maybe there is more truth in the old traditions than you might first think.

Halloween – October 31

It's not all ghouls and ghosts at Halloween. An old Irish tradition is baking a barm brack (Ir. *báirín breac*), a fruit cake into which a plain ring is placed before baking. Whoever finds this ring is thought to find his or her true love within a year.

New Year's Eve – December 31

You may just see it as a night for great parties, but the Scottish word for New Year, Hogmanay, comes from *Hoog Min Dag*, which means "Great Love Day" – and then there's all that kissing at midnight. There are numerous

sensual superstitions based around the New Year, not least of which is "first-footing," making sure the first person to pass through your door after midnight is a tall, dark, handsome man. This is thought to bring luck and help women find a partner in the coming year. Then again, if you get a tall, dark, and handsome man in your house after midnight, chances are your seduction prospects are already pretty high.

To banish bad love experiences, try the Spanish custom, known as *limpieza*: Thoroughly clean your house and wash all your clothes. Sweeping the rubbish out of the front door is thought to sweep out all the past year's experiences, paving the way for exciting new opportunities.

You may think that it's all nonsense, but you never know until you try. And, other than eating a salt-filled egg, the traditions are all harmless enough, so why not throw your skepticism aside and give it a go? After all, the more help you have in your mission to seduce, the better.

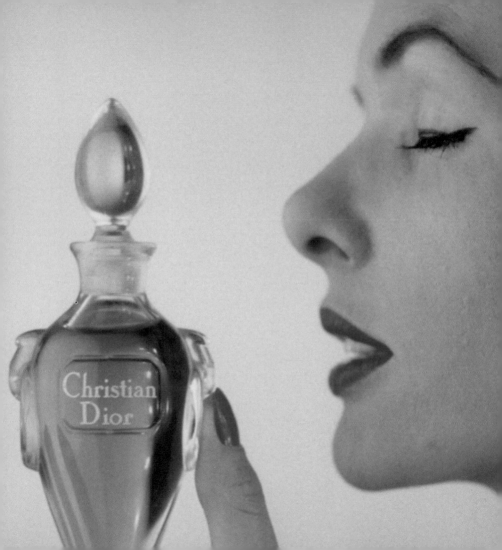

Seductive Scents

"Wherever one wants to be kissed."

> – Coco Chanel's answer, when asked
> where one should wear perfume

The power of perfume cannot be overestimated. Marilyn Monroe famously slept wearing nothing other than her Chanel Number Five, and seductresses dating back thousands of years have used perfumed oils to add to their sensual appeal.

Despite the millions of pounds spent by the perfume industry to convince us otherwise, the most effective aroma that a woman can have is her own. Pheromones are nature's love drug, serving a useful biological purpose. We are attracted to people whose pheromones show that they have complementary immune systems to us. At root, it's all about procreation: If you smell particularly appealing to a man, it suggests that you'll be a good mother for his children.

Although pheromones are found in your armpits, among other places, that doesn't mean that you should neglect your personal hygiene. Pheromones are sexy. Old sweat isn't. So make sure that you've washed, but don't use perfumes that are so heady they mask your natural scent. Going for perfumed body lotions and eau-de-Cologne is a good way to give yourself a subtle scent without drowning out your personal perfume.

But it's not just your pheromones that are valuable for seduction. Researchers at the Smell and Taste Foundation

Where to use seductive scents

Ensuring that you smell good is only one part of the story. A true seductress makes sure that her surroundings smell as sweet as she does. Try these tricks to boost your boudoir's passion potential:

• Sprinkle a few drops of your chosen perfume or oil onto a piece of tissue or cloth, then rub it over a lightbulb (when the light is off and, if it's a lamp, unplugged). Be careful not to use any flammable oils, and make sure that you keep the perfume well away from the base of the lightbulb (you don't want it getting into the socket). When you turn the light on, the aroma will be delicately released as the lightbulb heats up.

• Use a scented spray for ironing. Rather than buying expensive ready-made sprays, just add a

few drops of your preferred perfume to a spray bottle full of water. Use this spray when you iron your bed linen to make your bed smell ultimately inviting.

• Sprinkle some perfume onto a tissue or piece of cloth, then tuck it on top of your radiators.

• Use incense or oil burners – but never leave anything that's burning unattended.

• If you're lucky enough to be able to find scented roses, buy armfuls of them and put them in every room in the house.

True seduction is about overwhelming every one of a man's senses with desire for you and, by ensuring your surroundings smell sweet, you're hitting him at a subliminal level. It's a dirty trick, but all is fair in love and war.

in Chicago have found that men are particularly attracted to certain scents. Overall, the top-rated seduction smells are buttered popcorn and pumpkin – making the cinema an ideal place for a seductive date (and Halloween the ideal time!). Licorice, doughnuts, and lavender are also highly rated, while vanilla is particularly arousing to older men.

Some people swear by wearing a signature scent, and it can certainly be a good way to make a man recognize you the second you enter a room. However, if you're in a long-term relationship and need a seduction booster, try changing your scent for a while. Your partner may not recognize what's different about you, but he'll know something is – and men tend to respond well to variety.

Then there's aromatherapy. Used for thousands of years, and referred to in books as ancient as the *Kama Sutra*, some of the many aphrodisiac oils include ylang ylang and sandalwood. Jasmine is known as the scent of sacred love, and rose is another glorious seduction aid; Cleopatra was

reputed to have carpeted her bedroom in rose petals to aid her seduction of Mark Antony.

Indeed, Cleopatra was a big fan of aromatic seduction. She's thought to have saturated her body and clothes in incense fumes to help her enslave men. Her own particular incense blend comprised winter's bark, sandalwood, orris root, patchouli, myrrh, and frankincense, with a wood base. She also added saltpeter to make the incense sparkle when burned, but that's probably best avoided if you don't want to set fire to your curtains.

If making your own incense seems too much like hard work – and let's face it, for most people, it will be – then there are numerous sensual blends that can be bought inexpensively. Just focus on scents like sandalwood, rose, or ylang ylang for maximum seduction power. Whichever you choose, one thing's for sure: By harnessing the power of perfume, you'll be a truly scent-sational seductress.

Seductive Fabrics

Seduction should involve all the senses, so making your environment and dress as sensual as possible will reap rewards. Using the right fabrics to dress yourself and your boudoir is a great weapon to add to your seduction arsenal. Some of the sexiest fabrics include:

Leather: As Emma Peel showed in *The Avengers*, few things are sexier to men than a gorgeous woman in a leather catsuit. Although most of us haven't got a body that would suit an outfit that tight, you can still use leather as a seduction aid by wearing a fabulous jacket or

great pair of leather trousers. Or you can simply use leather furnishings in your house. The Smell and Taste Foundation found that leather was another top-rated sexy smell, and car manufacturers even add artificial leather smell to boost car sales, so there's got to be something in it.

Lace: Concealing as much as it reveals, the appeal of lace is obvious. Men like to be teased rather than see everything on display and will be fixated by a sheer lace outfit, hoping to get a glimpse of something they shouldn't. Cotton or silk lace is far sexier than synthetics, and less likely to irritate your skin.

Velvet: The plush pile and sumptuous feel makes velvet a fantastic fabric to add decadence to your surroundings. Think harem-style piles of big velvet cushions, thick velvet curtains that block out all light, letting you and your lover forget the time and indulge in your own private world, and even sensual velvet bedding to snuggle into.

Silk: Helping you stay cool when it's hot and stay warm when it's cold, silk is one of the most adaptable, and sensual, fabrics. Use it for bedding, nightwear, and lingerie to add seductive appeal. After all, what could be sexier than a silk negligée subtly skimming your body, showing your curves in all their glory, leaving your partner with only a wisp of fabric to remove?

Satin: As a more durable cousin of silk, satin is ideal to use for curtains and bedding: Who can deny that slipping between satin sheets is a seductive experience? And a satin slip dress is bound to get you attention of exactly the right kind.

Fake fur: Fake fur throws and rugs will add animal passion to your boudoir. And if you wear a super-soft fake-fur coat, don't be surprised if strange men come up and ask if they can stroke you.

If you're still not convinced that fabric can make a difference to your seduction efforts, ask yourself this: If a man came up to you wearing a polyester sweater and nylon trousers, how likely would you be to say yes to him? Right. So get out and get some silk today.

Seductive Colors

Color is another important part of seduction. Certain colors attract while others repel; it's part of nature. Animals realize that colors like yellow signify danger (think of a wasp), whereas red is highly suggestive (think of baboons' posteriors!).

As humans, we're a bit more sophisticated, but not much. Color psychologists have discovered that people respond differently to different colors. Making sure that you use colors to send out the right signals will add to your seductive powers.

Red: As the color of love, red is the ultimate in seductive tones. It stimulates a faster heartbeat and faster breathing. Feng Shui experts believe that red is a good color to add passion to your love life when used in the bedroom. One word of warning, though: Men who are intimidated by powerful or sexual women find the color red a turnoff, so don't wear it if you prefer to go for a more innocent facade.

Pink: As the most romantic color, you'd think that pink would be good for seduction, but handle with care. It can be draining; indeed, some sports' teams paint the changing rooms used by opposing teams bright pink to make them lose energy. If you need something to put you off using pink as a color to seduce, just think of Barbara Cartland.

Green: Worn by brides in the Middle Ages to signify fertility, green is the color of nature. It's refreshing and calming, so if you don't want to go for an obviously

seductive color but want your room to be conducive to love, green is the perfect color to go for.

Purple: This is best avoided. Although it has an association with royalty and opulence, psychologists claim that purple is the color of sexual frustration. That said, Cleopatra loved the color to such an extent that she had her servants soak 20,000 Purpura snails for 10 days to obtain one ounce of Tyrian purple dye, so it clearly worked for her.

Blue: A calming color, blue is all very well for helping you to relax, but it is best avoided in the bedroom. It's the polar opposite of red, and means coldness – never a seductive thing. However, if a man wears blue, it can be a good sign, as it suggests he is loyal.

Yellow: Because it's the color of fear, you should avoid using yellow at all costs. People lose their tempers more in yellow rooms, and babies cry more. Caterpillar green-

yellow has been found to be the least seductive of any color. On the plus side, it is thought to speed metabolism, so if you're trying to lose weight, then it does have its uses.

Black: As the color of authority and power, black is the seductresses' friend; after all, seduction is power. The ancient Egyptians revered black because it was the color of the fertile soil along the Nile. If you wear it to seduce, temper it with a flash of color like red or peach to increase the femininity of your look.

Most important, wear colors that you feel comfortable in. It's all very well wearing scarlet to attract men, but if it makes you feel sallow and unattractive, then it will be counterproductive. Being confident will always get you farther than anything else.

Creating a Boudoir

Now that you have the basics on color and fabric, it's time to put your mind to your boudoir. Every woman should have a bedroom that makes her feel like a seductress. After all, it's far easier to be sexually confident if you're in the right setting.

First of all, pick the colors and fabrics you're going to use. You may want to go for a red passion palace, or perhaps a more calming green space, with huge, white, fake-fur rugs. Pick a style that makes you feel comfortable, taking the guidelines about color and fabric into account.

Once you've got that sorted, it's time to move on to furnishing and accessorizing your room. Certain ingredients will make any bedroom more seductive.

A gorgeous bed: You spend a third of your life there, so it makes sense to invest in your bed. Make sure that the mattress is comfortable. Regularly oiling the hinges on your bed can save embarrassing (and nonseductive) squeaking. And you could always splurge and buy yourself the ultimate in seductive bedroom furniture: a four-poster bed. They can be found for under $500, and what price is that for feeling like a princess?

Make sure that your bedding is seductive, sweet-smelling and clean. If silk or velvet doesn't appeal, Egyptian cotton feels fabulous against the skin. Spray perfume on your pillows, and maybe add a fake fur or velvet throw over the end of the bed for extra opulence.

A seduction box: The path of true love can run smoother with props: feathers, silk scarves to run over each other's skin, massage oil, and all those other sensual essentials. Buy a beautiful chest to store next to the bed and fill it with everything you could possibly want for a seductive night in.

Things that should never go in a boudoir

While certain things can add that seductive ambience to your boudoir, others will destroy the mood quicker than you can say "passion-killer." These items are best avoided:

- **Any mess:** Your bedroom should be clean and tidy. Pizza boxes, empty cups, and discarded underwear don't make for seductive surroundings.

- **Pictures of ex-boyfriends:** Think of your potential partner's ego. A picture of an ex shows that you're not over him – particularly if you're in it, too.
- **A television:** The bedroom should be there for love, not leisure. Similarly, don't have a computer or anything else work-related in the bedroom, as it will only act as a distraction.
- **Cuddly toys:** They suggest that you haven't moved on since you were eleven – not a seductive thought.

Your bedroom should make you feel sexy, happy, and relaxed. The golden rule is that if something doesn't contribute to one of these factors it shouldn't be in your room.

Flowers: The Goddess of Love, Aphrodite, was also the goddess of flowers, so it makes sense to include a vase or two in your room to add to the erotic appeal. Make it even more effective by using the language of flowers to say what you want: A bunch of poppies and tulips will certainly send out the right message.

Pink carnations – I'll never forget you

Red carnations – my heart aches for you

Daisy – loyal love, innocence

White chrysanthemum – truth

Dandelions – faithfulness and happiness

Red roses – true love

Poppy – pleasure

Tulip – perfect lover

Candles and incense: Making the room smell great with incense or oils should be a given, and candles – particularly scented ones – can add a seductive ambience. Added to this, candlelight is incredibly flattering, making your skin tone appear more even and your pupils dilate so that you look even sexier. Is it any wonder that a candle-lit meal is such a popular scenario for a date? Just make sure you keep any candles well away from anything flammable – and not too near the bed, in case they fall over should it start shaking.

Other ways to add ambience with lighting include lava lamps, twinkling lights, and colored lightbulbs.

If you've got a limited space to work with, like a studio apartment, it's worth considering getting curtains fitted around your bed. That way, you can lock the world out when you're indulging your seductive self.

However you decorate your boudoir, rest assured that escaping into a passionate place away from the rest of your life is a truly sensual treat. It's hard to feel unappealing when you're in sumptuous surroundings, but a bit of candlelight and fake fur will help you feel like a princess.

The Science
of Seduction

When it comes to looking good, there's one thing that screen sirens as diverse as Marlene Dietrich and Marilyn Monroe shared, lookswise. It's called the Golden Ratio, and it shows that beauty is not so much in the eye of the beholder as it is an exact science.

Researchers looking at beauty have discovered that no matter what culture you're from and no matter what

period in time you're looking at, beauty can be tracked using a mathematical formula.

Don't panic, you don't need to have a science degree to understand the theory, although your algebra classes might finally come in handy. According to the research, beauty can be defined using the Golden Ratio of 1 to 1.618. In layman's terms, this means that the body is divided up into various zones, each of which can be analyzed using this ratio; for example, the distance from your navel to your toes should be 1.618 times longer than the distance from your navel to your head, and your lower arm should be 1.618 times longer than your upper arm.

> *"Men have charisma; women have vital statistics."*
>
> – Julie Burchill

A scientist named Dr. Marquardt has made it easy for you to tell how objectively gorgeous you are by making a mask

of the "perfect" face. He created a Golden Ratio-based arrangement of 40 "Golden" decagons of six different sizes, aligned with the face's various features. In tests, people find faces that fit with the Golden Ratio more attractive than those that don't. If you want to test your innate beauty, you can get a copy of Marquardt's mask at http://www.beautyanalysis.com/ and apply it to your face.

So what use is this to you when it comes to seduction? Well, quite a lot. You can use makeup to bring your face closer to the perfect Golden Ratio face: Pluck or fill your eyebrows, thin down or plump up your lips, shade your cheeks to emphasize your cheekbones, or shadow your nose to make it appear thinner or wider.

Similarly, you can dress to bring your body closer to the Golden Ratio: Wear heels if your legs are too short, or a hat if your upper body is too short. Men will be more attracted to you if you fit the Golden Ratio – even though they'll have no idea why.

Preparing Your Body
for Seduction

If you're planning a seduction, it helps if you've spent time pampering yourself first. Seduction may be more about the mind than the body, but that doesn't mean that your body is irrelevant.

"There are two reasons why I'm in show business, and I'm standing on both of them."

– Betty Grable

Keeping your body toned will undoubtedly help in your seduction efforts; not only will you look better, but you'll also have a higher libido if you keep yourself fit and healthy. It may sound boring, but doing that half-hour of exercise three times every week will help you keep in shape for seduction.

Pay particular attention to your favourite asset, be it your legs, back, or derriere. If you're going to be showing off a part of your body, it makes sense to present it in the best possible light. So if you love your legs, keep them perfectly shaved or waxed, and if your derriere is your best feature, do the old "squeezing your muscles" trick when you're sitting on the bus or at the office; no one else will notice, but your lovers certainly will.

But it's not just about keeping fit and healthy. Any woman can boost her seduction chances by paying some attention to her beauty routine when she goes out for the evening.

And, let's face it, it's not exactly arduous having to spend time pampering yourself.

Start off with a warm bath – not too hot or it will dry your skin. Add an aphrodisiac aromatherapy oil to the water to give you a subtle but evocative perfume and some moisturizing bubble bath to help soften you all over.

Buff your body with a loofah or scrub, paying particular attention to areas of rough skin, like your knees, elbows, and feet. You want every inch of you to be blissful to touch. Even if you're not going to let a man lay a finger on you, knowing you're perfectly strokable will give you that all-important inner zing.

When you get out of the bath, give yourself a pedicure – long toenails are hardly the most sensual thing in the world, whereas carefully painted ones will add extra glamour to your look.

Smother your body in a sensual body lotion or oil to give that layered aroma. Finish with a discreet dab of perfume and then move on to perfecting your makeup.

It may seem as if you're spending a lot of time preparing, but anticipation is sexy.

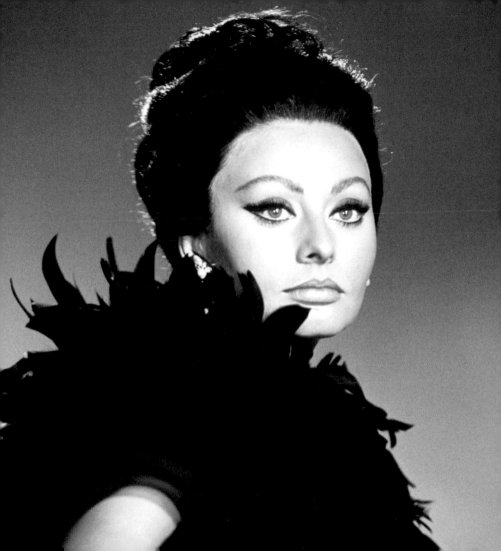

Makeup to Seduce

Too much makeup is an enemy of seduction; you want a man to imagine your hair spread out elegantly on his pillow, rather than your makeup caking it. That said, a light touch of deftly applied lipstick and liner can help improve your chances of seduction.

Eye makeup: Of all the facial features to emphasize, the eyes are the most important. They're the second thing that a man looks at when he notices a woman (the first being a toned body). Think of Cleopatra or Elizabeth Taylor – the queens of the bedroom eyes – and you'll get the idea.

Invest in a pair of eyelash curlers – they make any woman's eyes look bigger. And smoky gray eye-shadow with subtly applied black eyeliner will almost always be seductive.

Lipstick: It is said that the lips are a "genital echo." Researchers have found that men respond best to red lipstick, but if that's too vampish for you, go for a tone that's slightly darker than your natural lip color and add a slick of gloss for that "licked your lips" pout.

And the rest: As a general rule, avoid fashion when it comes to makeup. Bright colors may be funky but they're not seductive. Keep it simple: a delicate blush, which simulates arousal, and a dab of powder to give you a youthful glow. Men are attracted to features that imply youth – large eyes, dewy skin – so if you don't have it, fake it (a rule that never applies in the bedroom).

Once you've got your makeup sorted, you're ready to get dressed to kill. Or at least severely maim.

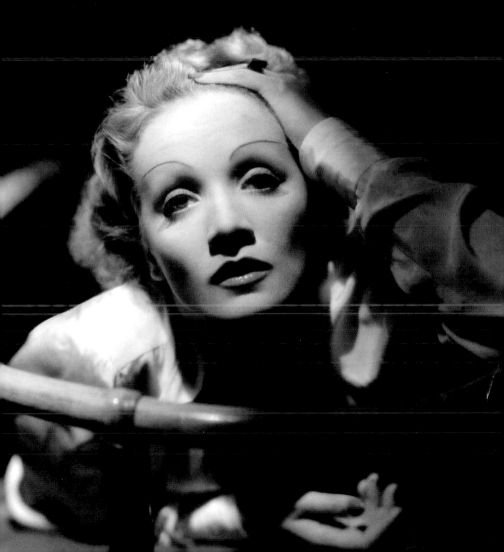

Lingerie

"If love is blind, why is lingerie so popular?"

– Anonymous

Ask a man what he finds seductive in a woman and nine times out of ten he'll say "stockings and garters." And while it's true to say that it's what is inside that counts, attractive packaging can add that extra oomph.

Seductive underwear is as much about what you conceal as what you reveal. Few men will be able to hold back their ardor at the sight of the naked flesh between stocking top and garter. And given the choice between wearing a

perfectly fitted corset or going naked, which would make you feel sexier?

> *"I often think that a slightly exposed shoulder emerging from a long satin nightgown packs more sex than two naked bodies in bed."*
>
> – Bette Davis

Particularly seductive items include seamed stockings, satin garter belts, and push-up – but never peephole – bras. As long as you get the right size, you can avoid unsightly bulges, no matter how big you are. Thigh-highs can stand in for garter stockings in a pinch, but are best avoided by all but those with matchstick-width thighs, as the rubberized tops can leave unattractive red marks when you peel them off.

A fitted corset or basque can also go a long way. Men are most attracted to women with a 0.7 hip to waist ratio, so

Lady or a tramp?

Sometimes it can be hard to strike the balance between sensual and cheap. You want to look seductive rather than easy, so follow these guidelines:

• Lingerie is classiest in one of three colors: cream, black, or red. However, you do need to be careful with red. As a general rule, darker is better. It's more flattering and less likely to look trashy.

• Always go for natural fabrics rather than synthetics. As well as looking and feeling classier, it's better for you.

• If in doubt, go for understatement. Side ties can be sensual on lingerie. Sheer fabrics can be sensual on lingerie. Jeweled trimmings can be sensual on lingerie. But put all three together and you're heading for disaster.

• Crotchless panties are never seductive. Ever.

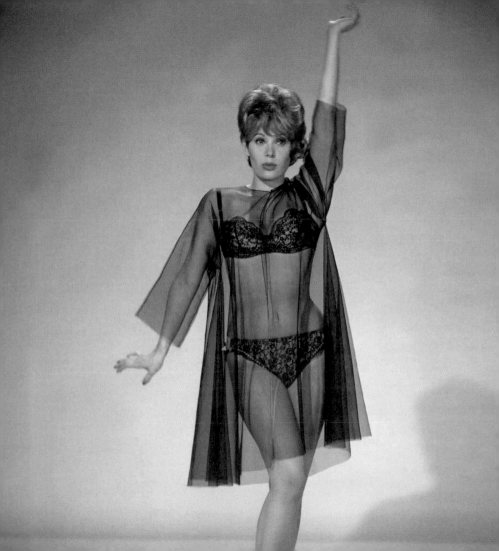

that's the effect you're aiming for (don't go overboard cinching in your waist, though – being in pain isn't seductive).

To find out your hip–waist ratio, divide the size of your waist by the size of your hips: for example, a woman with a 28-inch waist and 34-inch hips has a 0.8 ratio, and one with a 24-inch waist and 34-inch hips has a 0.7 ratio. Larger ladies will find that a corset cinches the waist while emphasizing the bust, and petite women will find it adds more curves to their figure by boosting their breasts.

"Brevity is the soul of lingerie."

– Dorothy Parker

· 113 ·

Many women spend all their money and attention on what goes on top, neglecting their underwear. But good lingerie is an investment in your future relationships – and surely it's worth spending money on?

The most important thing with lingerie is to wear something that you feel confident in. Don't be ashamed of your body; if you're in a seduction situation, the man clearly finds you attractive. And if you can wander around in next to nothing, without a care in the world, then he's going to be desperate for more.

"Underwear makes me uncomfortable and besides, my parts have to breathe."

– Jean Harlow

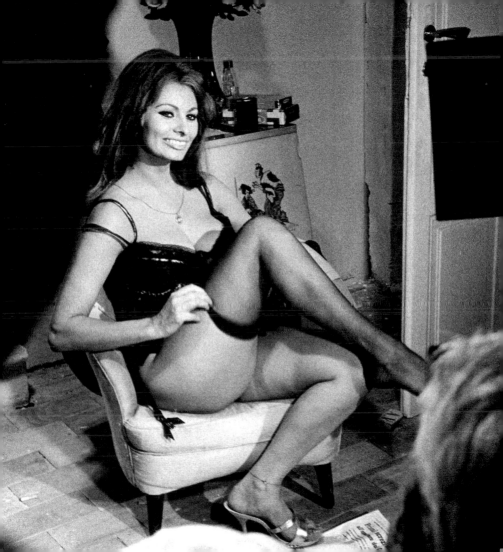

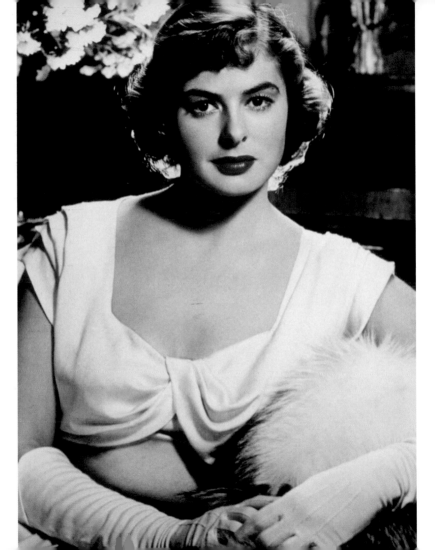

The Perfect Packaging:
What to wear to seduce

Wearing the right lingerie is all very well, but it's unlikely that you'll be showing it off early in the evening (that's more slapper than seductress), so you need your outfit to work magic as well. Strokable fabrics and seductive colors should be a given.

Clothes can be used to emphasize your best assets and hide any features you're not as happy with. But don't think that

seductive clothes have to be minuscule and clingy. Even the great Mae West knew that it's better to tease than to have everything on display.

> *"I like my clothes to be tight enough to show I'm a woman, but loose enough to show I'm a lady."*
>
> – Mae West

A good seductress knows the rules of balance: If you wear a low-cut top, team it with a long skirt or trousers. If you're wearing a miniskirt, go for a high-necked top. Go with vibrant color or sparkle, never both. You don't want to look like a ballroom dancing contestant.

· 118 · Never wear an outfit for the first time when you're aiming to seduce. If you do, you can guarantee you'll discover that the dye comes off, it digs in uncomfortably, leaving ugly red marks, or it wrinkles so badly that you look like a scarecrow in seconds.

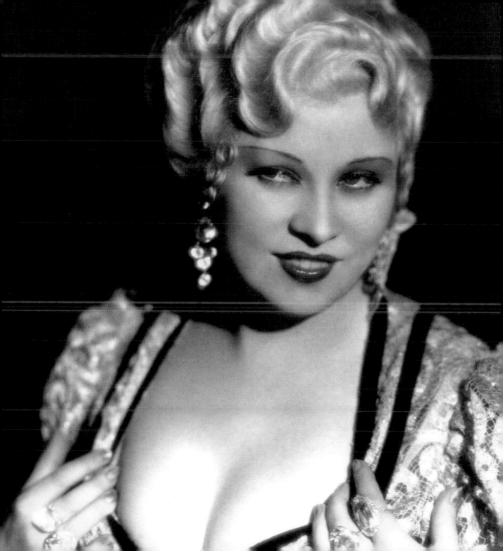

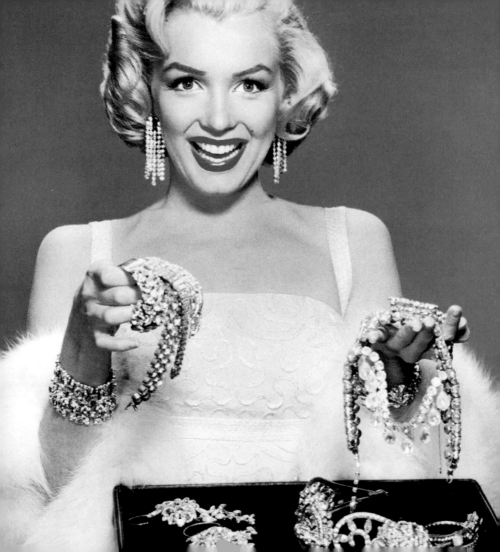

The finishing touch

Accessories can also play a part when it comes to seduction. According to research, men find women wearing long earrings more sexually attractive than women wearing no earrings, or studs.

Necklaces can be used to draw attention to your cleavage – go for a pendant that hangs just above it, and men's eyes will be naturally drawn there (as if they're not already).

If you wear glasses, use them. Men respond well to a steamy glance delivered over the top of your glasses.

And it's hard to deny the elegance and erotic appeal of a pair of long evening gloves – though only if you're wearing an appropriate dress to go with them!

> *"A woman's dress should be like a barbed-wire fence: serving its purpose without obstructing the view."*
>
> – Sophia Loren

It's also worth thinking about whether you're likely to end up removing your outfit in front of your object of desire at some stage in the evening. If so, make sure that your clothes are easy to get out of: no complicated hooks and eyes up your back or skin-tight clothes that require wriggling to remove. And bear in mind that it's almost impossible to remove a body seductively (not to mention that it limits your lingerie choices).

Above all, make sure that your outfit makes you feel fabulous. It's better to wear a pair of jeans that make you feel like a million dollars than a slinky frock you feel embarrassed to wear.

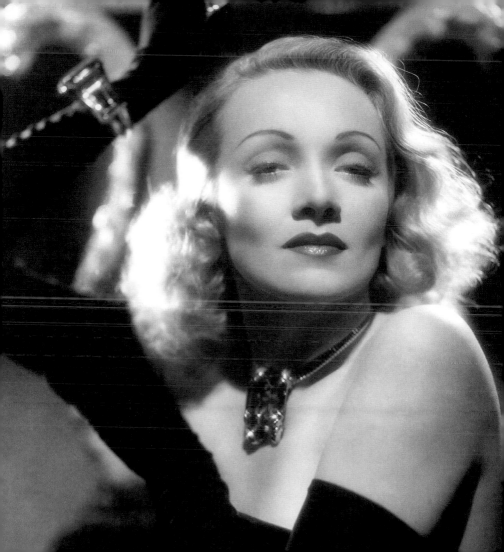

Perfect Timing

"The longer they wait, the better they like it."

– Marlene Dietrich

Nowadays, it's easy to believe that leaping into bed within seconds of meeting a potential mate is the way to go, but if you're aiming for seduction, making a man wait can reap rewards. Anticipation is a wonderful thing – and there are still, sadly, men out there who think, "Why buy the cow when you can get the milk for free?"

Of course, a seductress is sexually empowered, so it's not a case of playing games to get what you want. It's more about waiting until you're sure the man is worthy of your affections.

It's also a shame to miss out on all those "early days" experiences by jumping straight into the bedroom. Kissing for hours on the sofa, fully clothed, will help build the anticipation. By enjoying the frisson of holding back, it will be more fun when you decide not to.

"In the art of love, it is more important to know when than how."

– Evan Esar

There are certain landmarks that it's worth passing before you move into seduction mode. Has your object of affection called you – when he said he will – at least once,

and ideally several times? Have you had at least one date in which you felt like a princess, not necessarily because your man spent a fortune on you but because he treated you with respect and affection? Are you secure enough to be able to pick up the phone and call him when you want to talk? And, most important, are you sure that you want to seduce him? If the answer is yes, go for it. If not, give it some more time.

> *"Do you want me to seduce you? Is that what you're trying to tell me?"*
>
> – *The Graduate*

· 128 · If someone tries to force the pace and isn't prepared to wait, chances are they won't be around for that long after you have seduced them. If you're happy with that, go ahead, making sure you practice safer sex. But if not, you'll save yourself a lot of heartbreak by holding out that

little bit longer. More to the point, you'll have great fun. There's a lot to be said for courting. Remember, all good things come to those who wait.

> *"The absence, the declining of an invitation to dinner, an unintentional, unconscious harshness are of more service than all the cosmetics and fine clothes in the world."*

> – Marcel Proust

For the optimum seduction, it's also worth making sure that you both have enough time to dedicate to the task in hand. Don't go for a first-time seduction when either of you have an early meeting the next day. Try to time your seduction at a time when you've got your place – or his – to yourself. Roommates knocking on the door will do little to create a romantic ambience.

It's also worth being sober the first time that you seduce a man. Although it may seem like a terribly good idea to take things to the next level after you've had a glass too many of wine, from a practical point of view, sobriety is the friend of seduction.

When it comes down to it, chances are you'll know when the time is right: The lights are low, you've been chatting and laughing together, and, if not love, there's genuine affection between you. Then it's time to set your inner vixen free.

Where to Seduce

"Good sex begins when your clothes are still on."

Masters and Johnson

You may think it's just a case of "Your place or mine?" but seduction starts long before you get intimately acquainted. It's about lingering glances, innocent brushing of dust off a man's arms, laughing together, and generally showing off your fabulous personality in all its glory. With the right buildup, by the time you end up alone together, the man will be well and truly ready to make that first move.

With this in mind, you need to make sure that you're in an appropriate venue to let your personality shine through. The cinema is less than ideal because you can't talk, but the darkness will make it more likely that things just leap straight into the physical realm. Similarly, a noisy club where you have to shout to make conversation will do you no favors.

Instead, go for a classy bar or café that's not too crowded, but not so quiet that the manager can hear every word you say. Make sure it's somewhere with tables that are small enough for you to lean over to hold your date's hand, and vice versa. Those low couches and big bar tables may be great for a night out with a group of friends, but they're not conducive to seduction.

A candlelit meal is never a bad idea either: Not only is candlelight flattering to your skin tone but you also get a chance to discover what your date is really like, by the way that he behaves during the meal.

First of all, note what he orders. If he goes for the cheapest thing on the menu, he could have self-esteem issues or be mean. On the positive side, he may be trying to save your wallet, so it's not always a bad sign.

If he tries to order for you, then he's a misogynist. He can recommend things if he knows the restaurant well, but choosing for you suggests that he will be controlling, in and out of the bedroom – and not in a good way.

However, if he goes through the menu saying, "Mmm, escargot with garlic butter, asparagus, baked mozzarella and . . . oh, it all looks so good," you could be in for a treat.

Next, how does he eat? If he insists that you try some "because it tastes incredible" and dives in, savoring every mouthful, prepare for fun. Conversely, if he pushes his food around the plate and is only able to take a couple of mouthfuls, it can also be a good sign. Attraction is a great appetite inhibitor. But if he complains about everything, is

rude to the waiter, and only takes a few bites before pushing it aside, he's not worth seducing. Unless the food is truly awful, there's no excuse and he'll probably be too demanding for a seductress like you to waste her time on.

Of course, the date has to come to an end at some stage, and then you're into the "your place or mine" routine, if he's proved himself worthy of your charms. For your first seduction attempt, it makes more sense to go for a home game. You can set the ambience in your beautifully designed boudoir. And you don't have to deal with the morning after without access to all your makeup and bath products.

If a man is interested enough to be worth having, he won't mind where you go. All that matters is that he gets to go there with you.

"Women need a reason to have sex. Men just need a place."

– Billy Crystal

Body Language

"I speak two languages: body and English."

– Mae West

The power of body language should never be underestimated. It accounts for at least 55 percent of communication and a good seductress knows how to read and speak it fluently.

Being aware of your own body language is the best place to start. You should avoid "closed" postures: anything in which your arms or legs are crossed in front of your body. Both these postures put a subconscious barrier between

you and your potential amour – not the effect you're going for. Train yourself to have an "open" posture with your arms open and your hands unclenched, and you'll look approachable, friendly, and desirable.

Another classic "come hither" signal is echoing (copying) your partner's posture – if he leans back, you lean back. If he leans forward to rest his chin on his hand, wait a few seconds and do the same. It sends him a subliminal message that you're a similar type of person to him, which will make you seem more attractive.

Be tactile – make small touching movements, lightly placing your fingers on "safe" areas of his body, like his shoulders, arms, and wrists. This brings you into his space – and if he doesn't pull back, you're on to a winner. Similarly, use hand gestures and nod a lot to show that you're welcoming him into your space.

Your eyes are another essential for effective seduction. You can use eye contact to attract attention in the first place or to intensify the mood. Don't stare at your partner. Just look into his eyes for longer than would be usual with someone, look away, then glance back. Widen your eyes too. When you're attracted to someone, your pupils dilate (get bigger), making you look more appealing – something that you can boost by thinking erotic thoughts.

If you can communicate with your eyes what you want to do with the rest of your body, you'll get his pulse racing almost as much as you will with hot and heavy action.

"Glances are the heavy artillery of the flirt: Everything can be conveyed in a look, yet that look can always be denied, for it cannot be quoted word for word."

– Stendhal

It may sound obvious, but don't forget to smile. Sometimes nerves can get the better of you and you'll sit there looking so serious that your poor date will wonder what he's done wrong. So show him how happy you are – and laugh at his jokes. If you moisten your lips with your tongue when speaking to him, you'll add serious seductive power to your smile.

"Beauty is how you feel inside, and it reflects in your eyes. It is not something physical."

– Sophia Loren

Stroking your hair is another good trick. It's seen as grooming behavior, and shows that you are interested in getting to know a man better.

· 143 ·

But by far the most powerful seductress's trick is the eye-to-lip glance. First, make eye contact. Drop your gaze in a

leisurely way to your object of desire's lips, then return to his eyes. Repeat this. By the third time you look at his lips, he'll be drawn to kiss you. This one has an unnervingly high rate of success.

Generally, be aware of what your body's doing, watch your dream date's posture, and soon your bodies could be getting far more intimately acquainted.

Body language at a glance

If he's interested, he may:

- Face you with his head tilted.
- Have his hands behind his head, touching his arms.
- Lean forward.

- Talk animatedly.
- Make lots of eye contact.
- Echo your body posture.

Show your interest by:

- Tilting your head to one side facing slightly away from him.
- Keeping your arms uncrossed.
- Flicking your hair.
- Touching nonintimate areas of your body: stroke your collarbone or neck, or put your hands on your hips.
- Leaning slightly backward.
- Keeping your legs relatively wide apart or repeatedly crossing and uncrossing your legs.

Speak Pure Seductress

"All really great lovers are articulate, and verbal seduction is the surest road to actual seduction."

– Marya Mannes

Given the amount of time people spend worrying about what they should say to a potential partner, you may be surprised to learn that a mere seven percent of communication is down to what you say; the rest is about body language and tone of voice. That said, being seven percent more seductive by saying the right things is not to be scoffed at, so it's still worth applying some thought to your verbal approach.

Seductresses eschew cheesy lines because they're just not classy: "If I could rearrange the alphabet, I'd put U and I together" may raise a smile, but could you really imagine a Hollywood screen siren saying it?

Instead, draw a man into your web, making him subtly aware that you're exactly the woman he needs right now and that if he plays his cards right, he may be lucky enough to get you.

Best to avoid...

Certain phrases are best avoided if you want to seduce a man. These guidelines will help you steer clear of them:

- Don't use words like "love" or most men will run a mile (unless you're talking about loving wearing lingerie...).
- Avoid "lines" – they work only if someone's already interested anyway, but they make you look desperate or, at the least, lacking in class.
- Don't talk about previous lovers.
- Don't ask about his previous partners.
- Avoid talking about work too much; by all means let your passion for work come through, but avoid using jargon, and give him a chance to talk about his passions, too.
- When people get nervous, they often talk constantly to fill the gaps. Instead, listen as much as you talk. It will make him feel like the center of the universe, and thus feel good about you.

Don't be afraid of your sexuality: The right man will never feel intimidated by a woman who feels comfortable admitting that she desires him. Indeed, the ideal seduction conversation contains flattery, self-confidence and a hint of what's to come.

"Why don't you come on up and see me sometime, when I've got nothin' on but the radio."

– Mae West

Ask a potential partner lots of questions; it will make him feel as if you're genuinely interested – which you are. And every man enjoys talking about himself.

Try to establish areas of common interest, but if you know nothing about his pet subject, ask him to tell you more about it. He'll get to feel manly as he explains it to you – never a bad thing when it comes to seduction. Don't play dumb, though: it's patronizing to him, and to women

everywhere. If you need to fake being something you're not to attract a man, he's not worth having.

Most of all, relax. If you talk to your potential love interest as you talk to your friends, he'll get to see the real you. And that's the person who's seducing him after all.

"To speak of love is to make love."

– Honoré de Balzac

The vampish voice

While what you say isn't all that important, the way you say it can make a massive difference to your chances. It's so important that sweet nothings are literally that. In terms of seductive power, it doesn't matter what words you use

(within reason) as long as you speak in the right tone.

Your tone of voice plays a significant part in communication, so you need to make sure that your voice sounds as tempting as you look. Squeaky isn't sexy – could you imagine Marlene Dietrich without her husky drawl? Try to keep the tone of your voice as low as you can, without being unnatural. You may find this easier if you speak more quietly. This has the added bonus of forcing your target to move closer in order to hear you.

Keep your voice friendly. This can be boosted on the phone by grinning broadly. You may feel a bit foolish, but the positive tone it puts into your voice will get you what you want.

· 153 ·

The Way to a Man's Heart...

Aphrodisiacs have been used as a seduction aid for thousands of years. Casanova claimed that he started every morning lying in a bath eating oysters from a beautiful woman's breasts, and the *Kama Sutra* has an entire section devoted to the foods of love, including a milk and licorice blend and a variation of rice pudding made with sparrow eggs and honey.

From Casanova's oyster habit to Shakespeare's famous thoughts on alcohol "provoking desire but lessening performance," thousands of people have searched for the perfect potion to help boost libido and increase sexual desire. Luckily, you don't have to create any complicated recipes to seduce a man. You just need to have an idea of the ingredients that can light his fire.

Bear in mind that much of the power of aphrodisiacs is in the mind. Sensually sucking melted butter from asparagus is an erotic act in itself, regardless of the properties of the vegetable. The phallic symbolism paired with the opportunity for finger sucking will get most people's motors running. And that's what an aphrodisiac meal is supposed to do.

As a general rule, keep things light. Men's testosterone levels can plummet by 30 percent after consuming a fatty meal, which is the last thing you want.

Seafood is a good dinner option, as most shellfish has been attributed with libido-boosting qualities at some stage. The look, smell, and luxury of eating an expensive food, or even the fact that it's generally eaten with your fingers, have all been given as reasons why.

If he's vegetarian, you could do worse than cooking a nut roast. Walnuts were eaten at Roman orgies to help people stay energized, and pagans used hazelnuts in fertility rites. Serve it with baked fennel, thought to be a sexual stimulant by many cultures, including Greek and Hindu, or celery, which helps pep up blood flow to those all-important places.

Even if he's a traditionalist who wants his meat and two veggies, you can still prepare a seductive meal. Root vegetables are thought to draw power and intensity from the earth and reputedly transfer that power and intensity to your love life, so carrots and parsnips will help with your seduction. Avoid turkey, though. It contains

Don't go there

There are several reputed aphrodisiacs that really aren't worth the animal cruelty or just plain "ick" factor involved. Throughout the ages, people have believed that eating animal testicles will provide increased arousal. The Romans ate penises, wombs, and testes from animals, including monkeys, pigs, cocks, and goats. Tasty.

Rhino horns – now illegal – and antlers have been used in the hope of increasing men's libido, even though there's no proof they work, and black rhinos are an endangered species.

Spanish fly is another aphrodisiac with huge associated risks. A green beetle is dried and crumbled to dust. This dust, known as cantharidin, has the effect of irritating the urethra. While this

does increase the blood flow to the penis, it can cause priapism – a persistent erection. It can also lead to infections, gangrene of the penis, and even death. In Zimbabwe, traditional healers sell a similar product called vuka-vuka, another dried beetle with the component of cantharidin, which is also best avoided.

Then there are the numerous animal and insect preparations used: black ants dried and mixed with olive oil; lizards, pulverized and mixed with sweet white wine; snake blood; shark fins; and gallstones. Bet you feel hungry now.

Some preparations are cruel, others taste unpleasant, and still others can kill you, so be wary and never take anything you're dubious about. It's just not worth the risk.

tryptophan, an amino acid that makes you feel sleepy – not the result you're after.

When it comes to dessert, baked figs are a great choice – the erotic shape of a halved fig offering an obvious reason why. When teamed with aromatic vanilla – remember, the aroma arouses men – figs become a truly sensual treat.

Or go for a banana-based pudding. It's not just the shape of bananas that's suggestive; the potassium and zinc in them is good for increasing a man's sex drive. Adding chocolate or vanilla will increase the aphrodisiac quotient.

Cooking for a partner shows that you care about him: There's certainly an element of truth in the line that the way to a man's heart is through his stomach. And if you add aphrodisiacs to the equation, your seduction can start before you even leave the dinner table.

Tempting tipples

It's not only food that can be an aphrodisiac. Drinks can also be used to help you win the affection of the man you desire. That doesn't mean getting him drunk. Remember, alcohol generally lessens performance. Instead, try these:

Ginger tea: This fiery spice is thought to increase blood flow, boosting the libido by warming you up. As such, ginger tea – or even ginger beer – can be a libido-booster.

Chocolate drinks: Chocolate contains phenylethylamine or PEA, a psycho-stimulating chemical found at higher levels in the bloodstream of people who are in love. Chocolate also stimulates endorphin secretion, which promotes an opiatelike effect on the body.

The Aztecs brewed cocoalike coffee, and Aztec leader Montezuma is alleged to have drunk 50 cups a day so that he could keep up with his harem of 600 women.

If you are going to go down the alcoholic route, one ancient aphrodisiac drink is May wine. Traditionally made on May Day, it's a concoction of meadowsweet or woodruff steeped in white wine. Twenty-four hours after the herbs are added, the wine is cooled and fresh strawberries are added for an intoxicating – and apparently arousing – brew.

Alternatively, go with mead: honey made into a drink that was enjoyed by couples on their wedding night – hence the word "honeymoon."

If none of these float your boat, just have a glass of bubbly instead. It may not have specific aphrodisiac qualities, but it will always be sexy!

"Enjoyed it! One more drink and I'd have been under the host."

– Dorothy Parker

Mood Music

"If music be the food of love, play on."

– Shakespeare

Music has always been seen as a seduction tool. The *Kama Sutra* recommended that women learn how to sing and play musical instruments to help them seduce a potential mate, and more recently musicians, including Barry White, have become indelibly linked with seduction.

There is science to back up the theory of music as a seduction aid, too. Listening to rock music can increase adrenalin flow, making you feel more aroused. And there are even music fetishists – called acoustophiles – who become aroused purely from sounds. The middle C note is thought to be the most arousing – though that's probably not a lot of use when it comes to choosing what to put on the stereo.

Luckily, further research has found that 29 percent of men like slow and romantic music best when it comes to getting in the mood. Eleven percent find soft rock seductive, 10 percent go with R&B, and the same amount prefer jazz. Alternative music is found sexiest by 7 percent of men, as is techno music (somewhat surprisingly!).

Six percent of men go with heavy metal or rock and roll, 4 percent adore classical music to get them in the mood for love and 3 percent go with dance music. At the bottom of the pile is country and western – which isn't all that

much of a shock given the amount of songs in the genre that are about heartbreak.

Research aside, when it comes to picking out that seduction album, the most important thing is to go with something that you find sexy. If you're moving your body sensually to a track you love, chances are the man you're seducing will be so enamored, he won't mind what he's listening to.

"I conclude that musical notes and rhythms were first acquired by the male and female progenitors of mankind for the sake of charming the opposite sex."

– Charles Darwin

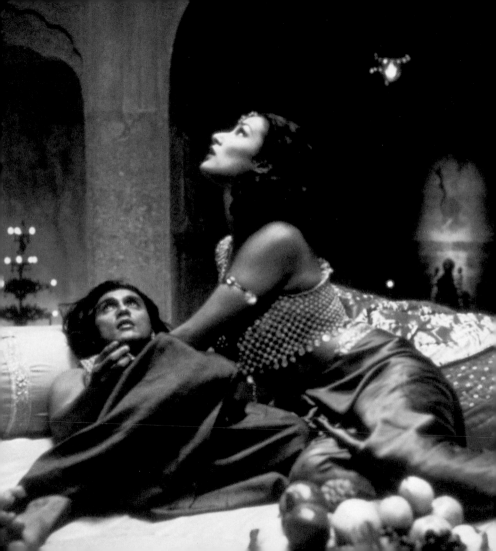

Massage

Assuming everything's gone according to plan, by the time you've finished an aphrodisiac-packed dinner and slipped the right CD into your stereo, things will start moving toward the physical. The seductress doesn't go straight for the kill, though. Instead, she teases, making the man desire her fully before things progress.

Massage can be a wonderful way to make a man crave more, without moving too fast. And it can be just as sensual for the person giving the massage as the lucky recipient; after all, what could be sexier than rubbing

aromatic oils all over the body of someone you desire?

While massage can be a spontaneous act, a bit of time and effort beforehand can turn a good massage into a great massage. Make sure that the room you're planning to massage your partner in is warm – goose bumps aren't exactly sexy.

Warm some towels on the radiator (or in the dryer), ready to cover your partner with should he get cold. Scented candles or incense will give a relaxing ambience to the room. And buy some aromatic oils, or a non-oil-based lubricant if you're planning on getting more intimate later, as oil isn't condom-safe.

· 174 · With all the preparation done, ask your partner to lie on his front on a bed or other suitable surface. Sit astride him, without resting too much of your weight on him – the last thing you want to do is hurt him.

Warm some oil between your palms and put both hands on the center of your partner's back, being careful to avoid his spine, as touching it can be dangerous unless you're a trained professional. Leave your hands on his back, resting for a minute or so, letting him anticipate what's to come and get used to the feeling of your skin on his.

Once he's relaxed under your hands, start the massage. There are two main kinds of erotic massage stroke: petrissage (kneading) and effleurage (stroking). Vary the way that you use these. If you're unsure of any of the strokes, practice on yourself first.

Move slowly and gently and use your body weight rather than the strength in your arms for deep strokes. If you find it hard to reach any part of your partner, move to sit on the edge of the bed beside your partner rather than astride him.

Types of massage strokes

Touching your partner in different ways will keep him constantly guessing, which is always a good thing for a seductress to do. Try some of these:

- Using long smooth strokes that follow your partner's curves.
- Fanning your palms out, then sliding your hands up your partner's body.
- Pushing your thumbs softly into any tense areas – these will feel tighter than other areas – and increasing the pressure to match your partner's comfort zones.
- Alternatively, when you reach tense areas, try kneading them with your knuckles.

No matter which strokes you use, ask your partner to tell you if he feels pain or discomfort at any point. And listen to his moans: Not only will they tell you if you're doing something wrong, but they'll show you if you're doing something right – and give you clues to his erogenous zones for later...

When giving an erotic massage, you may want to begin by gently stroking your partner's back, legs, and feet. Once you've finished on his legs and back, ask him to turn over, allowing you to move on to his chest, legs, arms, and hands. When massaging the legs you can gently glide your fingertips over your partner's genitals, but avoid getting too carried away. After all, you want him to be left craving more.

After you've caressed every inch of your partner's body, it's time to move from rubbing to kissing. Concentrate on his less obvious erogenous zones: his neck, chest, nipples, thighs, or even feet. Ask him if there's anywhere he particularly likes being caressed (but be warned – you can guess what his answer is most likely to be).

If you do decide to massage him more intimately, make sure that you use lubricant rather than oil, for safety reasons, as mentioned earlier. Cover your hands in your preferred lubricant and cup his testicles while you glide the heel of your palm up and down the underside of the penis, from the base all the way to the tip. Alternatively, stroke the penis from the top to the bottom with your left hand. When it gets to the base of his penis, let go, and bring your right hand to the top of the penis. Repeat the stroke and keep swapping hands so that he's constantly stimulated.

If you want things to get really steamy, hold your partner's penis in one hand and caress it gently for about ten

seconds. Then slide your hand rapidly down to the base of the shaft just once, before going back to another ten seconds of caressing. Be careful, though, this move is highly likely to tip him over the edge.

After that, you could end with a Thai or full body massage – where you slide your body sensually all over your partner's. This will stimulate all your nerve endings, and his, while being intimate and erotic. What could be more seductive than that?

Eastern Promise: Seduction tricks from the *Kama Sutra* and beyond

The *Kama Sutra* is one of the world's best known erotic manuals, but there's far more to it than the sexual positions it's famous for (there are actually fewer than forty sex positions in it). It was originally written to help everyone achieve "kama" – total fulfilment of body and soul. That may sound terribly deep, but the book is

basically an age-old seduction guide, covering everything from courtship to the sensual arts, like preparing aphrodisiacs. Most of the tips are as relevant today as they were when it first came out – not bad for a book that was written between 100 and 400 CE.

The *Kama Sutra* is a massive advocate of preparation, suggesting that you set the mood by preparing your body for seduction with rich perfumes. In common with other ancient texts like *The Perfumed Garden* and Japanese pillow books, it suggests you cover the floor with cushions, open the windows, burn incense, light candles or lay a fire, and put a clean throw on the sofa or clean sheets on the bed. It recommends that you scatter your bedding with flowers and put aromatic oils and more flowers next to the bed for the ultimately seductive setting.

Kissing is all-important in seduction, and the *Kama Sutra* has some sensual variations to try. Try the "greatly pressed kiss": Grip your partner's lower lip between two fingers,

touch it with your tongue, then press it hard against your lip. Or kiss his forehead, cheeks, and throat rather than just his lips.

After lengthy, impassioned kissing, stop, and just look into each other's eyes instead.

"Ancient lovers believed a kiss would literally unite their souls, because the spirit was said to be carried in one's breath."

– Eve Glicksman

Now join hands, clasping them palm to palm and feeling the energy flow from you to your partner and back to you, in a never-ending circle. As the connection builds, move to more physical contact, focusing on building the connection rather than directly stimulating your partner.

· 183 ·

Lie together in the spooning position and enjoy the closeness. Lie on your left side, curled into your partner with your back against his front, or vice versa, to align your chakras (energy centers). Softly stroke each other while you concentrate on your breathing. Pay attention to each inhalation and exhalation. Feel the breath flow from your nostrils.

Once you can easily focus on your breathing, start listening to your partner's breathing, and breathe in time with him. Allow yourself to become one with him.

You may feel so relaxed and in tune that you drift off to sleep. If you stay awake, try giving your partner a nonphysical orgasm. Place your hand about an inch or so above the skin of his base chakra, located in the perineal area. Let the energy flow build between you, and once you are both feeling a tingle or warmth, gradually drag the energy to the base of his spine, where Kundalini (sexual) energy resides.

Let the energy build further and slowly drag your hand – still an inch above his skin – up his spine and over his neck, stopping at each chakra (found in the navel, chest, throat, forehead, and top of the head) to let the energy build further. When you pull the energy through the crown chakra at the top of your partner's head, he may well experience contractions and extreme erotic sensations – an orgasm without physical contact or, indeed, physical signs such as ejaculation.

Now, that's a trick that any seductress should be proud to master!

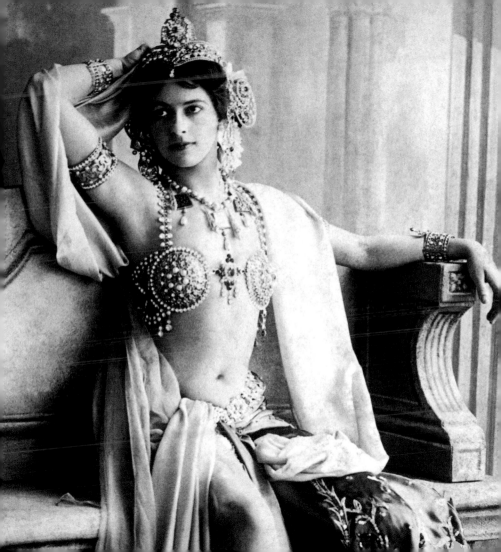

Seductive Striptease

If Eastern techniques are a bit too esoteric for you, a less · 189 · spiritual approach to seduction is a good old striptease. Contrary to what you might think, the teasing is as important as the stripping. It's not about getting your clothes off as quickly as possible. It's about making a man

worship you with his eyes – and hope desperately that he can worship you with the rest of his body later.

As with all aspects of seduction, preparation is vital. Start by picking out a song that makes you feel utterly seductive. Make sure there are no candles that you could knock over with an inaccurately thrown item of lingerie, and clear the room you're dancing in enough so that there's nothing to trip over. As with massage, having a warm room is essential for striptease.

Pick your outfit, deciding whether you want to go with a persona, like vamp or nurse, or your natural, gorgeous self. Make sure that you can dance in your chosen shoes. And practice your routine until you know exactly what you're doing at every beat of the song.

> *"The dance is a poem of which each movement is a word."*
>
> – Mata Hari

Concentrate on when and how you take each item off. Think of yourself as a gift, unwrapping yourself slowly, showing delight at each new part that you reveal. Never reveal too quickly: A quick peek and then hiding your body again can be far sexier than a full flash.

Eye contact and facial expression are crucial to striptease. Look at your partner and draw him in with your eyes. When you touch your body, look at the area you're touching to draw his attention to it. Be aware of how your fingers feel against the body part you're touching and communicate through your expression that you love the way it feels. And don't be afraid to smile; it's one of the sexiest things that you can do.

Remember that, as a performer, you have immense power and that this is seduction of the mind. Believe in yourself and you'll radiate sexuality. Show your partner how lucky he is to have you stripping for him. And most of all, enjoy it; you can be certain that your partner will.

Enemies of Seduction

You may think you know everything there is to know about seducing a man now, but stop! Before you get too complacent, it's worth quickly covering enemies of seduction – those things that, no matter how seductive you're being in every other way, will automatically kill the mood.

Bad breath: It should be obvious, but making sure you smell sweet is essential if you want a man to come close to you. Go for regular trips to the dentist, clean your teeth twice a day, and, if need be, use mouthwash and a tongue

scraper to make your breath smell sweet. If you eat garlic or some other strong-flavored food on a date, make sure that your partner has it, too, so that you'll balance each other out.

BO: Similarly, make sure that you wash regularly – both body and clothes – as stale sweat isn't the aroma you want a man to remember about you.

Drunkenness: This isn't a preachy "alcohol is bad" line. Whereas a couple of glasses of wine is fine, falling over, talking in a really loud voice without realizing it, and cackling over your own private jokes or, worst of all, vomiting over your partner are not the moves of a seductress. If you feel yourself heading toward getting drunk, get some water and drink it immediately. Not only will it help you sober up, but your hangover won't be as bad in the morning.

Crying: All men are terrified of women crying; deep down, they have a sneaking suspicion that it may be their fault. Crying is often teamed with drunkenness, which is another reason to avoid getting too inebriated.

If you start to feel sad about your ex, or have a need to cry for any other reason (unless you've just found out your kitten's died, or something more serious, and need a hug), sneak off to the john with your makeup bag, have a cry, and clean yourself up so he doesn't know what you've been doing. It's probably not the best night to move things to the next level, though...

Clinginess: Playing games isn't something the seductress does, but that doesn't mean that you should turn into a limpet. Enjoy space from your partner. It's not about giving him space; it's about both of you having time out to have fun, and eagerly anticipate the next time you see each other.

Conclusion

Now you should have all the ammunition that you need to go out and seduce the man of your dreams. You've got the power inside you, so all you need to do is set it free.

By making sure your body, boudoir, and, most important, brain are prepared for seduction, you will always be ready for Mr. Right (or Mr. Right Now).

Don't be afraid to add your own unique twists to your seduction techniques. Some women find that sending sexy text messages adds to their seductive appeal. Others truly let their inner vixen free when they're on the dance floor. Some get tips from watching sensual films, and others just put their lips together and blow. Your seduction technique should reflect you; after all, it's you that the object of your desire will be spending time with.

Oh, and one last thing. If you try to seduce a man and he doesn't respond, it doesn't make you a bad seductress – it makes him the wrong man. So move on and find someone who can appreciate someone as fantastic as you are. After all, you're the queen of seduction. Any man who can't see that clearly doesn't deserve to enjoy your talents.

"A woman who has the divine gift of lechery will always make a superlative partner."

– Alex Comfort

The publishers would like to thank the following sources for their kind permission to reproduce the pictures in this book.

Aquarias Collection: 81, 82, 96, 100, 104, 169

British Film Institute: 17, 132, 146, 170

Corbis Images: 68; /Bettmann: 52, 63, 187; /Blue Lantern Studio: 28; /Bob Flora/UPI/Bettmann: 99; /CinemaPhoto: 120, 124; /Collection Corbis Kipa: 92; /Corbis Sygma: 172, 180; /John Springer Collection: 71, 103, 184; /SunsetBoulevard/Corbis Kipa: 48; /Sunset Boulevard/Corbis Sygma: 108, 116, /Underwood & Underwood: 150

Getty Images: Housewife: 60; /Kurt Hutton: 135; /Tom Kelley/Hulton Archive: 8

The Kobal Collection: 12, 35, 36, 44, 72, 85, 112, 154, 196, 199; /Columbia/A.L. "Whitey" Schafer: 123; /Embassy: 18; /MGM: 162, 192; /Paramount: 31, 75, 76, 119, 161; /E.R. Richee: 107; /RKO: 127, 138, 166; /Selznick/MGM: 5, 32; /20th Century Fox: 188; /20th Century Fox/Jack Albin:89; /20th Century Fox/Ellen Von Unwerth: 56–57

Rex Features: Pierluigi Praturlon: 115; /Snap: 20, 25, 129, 141